Indie Film Production & Publicity

A Complete Guide To Success

By

David K. Ewen, M.Ed.

Copyright © 2012, Ewen Prime Company

Printed in the United States of America

All rights reserved. No part of this book may be reproduced or transmitted in any form or by any means. Electronic or mechanical, including photocopying, recording, or by any information storage and retrieval system without written permission from the publisher, except for inclusion of brief quotations in a review.

ISBN-13: 978-1470142759

ISBN-10: 1470142759

Publisher: Ewen Prime Company

To my

beautiful wife

Maria Ewen

3 Indie Film Production and Publicity 3

To Your Success

Did you ever see a fantastic movie and want to make your own to show an audience? Have you wondered how the film industry looks at theater, television, video-on-demand, lap tops, tablet computers, smart-phones? If you had your movie, how would you publicize it? What would make people want to watch it? How would you make that happen?

This book will describe a the many forgotten basics of the movie making business and then show how the publicity machine really works. You have the ability to create a quality film piece and present it to a wide audience. It doesn't have to be a full time endeavor. Also, it doesn't have to be expensive. Today's technology allows for film making that anyone can afford. You just need to be guided through the right tools for you to succeed. That's what this book does.

The business of film and movies is an art. Being an art, there are different slants of thought on the topic. Take this book as my slant and consider what is offered only a suggestion. I will not step on toes as I respect the art and the business of all film producers.

The goal of this book is to have you be proud of your success and to be excited to tell me about it. I truly want to celebrate your new or next film. It's hard work that deserves to be shared to an audience.

Contents

This book is in two parts

Page 05　　**Film Production**

Page 17　　**Publicity Made Simple**

The discussion of film production is small compared to the business of publicity. It's one thing to create a movie. It's a bigger thing to have people watch it and for you to be recognized for it.

5 Indie Film Production and Publicity 5

This section is called

Film Production

For some it's a beginning and for others, it is a reminder of what may have been forgotten. Either way, the experienced and the novice will absorb something valuable that hopefully will contribute to their success.

6 Indie Film Production and Publicity 6

History

I was inspired to provide content by all the authors I have worked with since 1994. I've been an author and writer for many years. Since 2004, my workshop seminar in book publishing has been taught at thirteen universities and colleges in four states. Very early, I learned how to produce content and deliver it in the written format.

My introduction to broadcast media was in 1998 when I hosted my first radio talk show on WORC 1310 AM and WGFP 940 AM. My first television show was introduced in the same year at the WCAT studio's in Westborough, Massachusetts.

After meeting my wife, we went to Connecticut to tape the talk show "Today's Music Review" for KCLA 99.3 FM in Los Angeles for the American Radio Network.

As an author, I have written many books, one that more recently was featured in a television interview on WWLP, Channel 22 news.

It was then, I wanted to provide content not only as an author, but as a studio director in film. This is when the Your World Discovered documentary series was launched. The films were streamed online and made available on DVD. The first formal presentation of the first few films was at Springfield Community Festival. The event was featured locally in Springfield, MA on CBS 3, Fox 6, and ABC 40.

Video With No Budget

If you have a zero budget ... and I mean zero ... you can still make a movie. Dollars won't stop the true passionate film maker.

In the world of film, the most important tool is the camera. But without other tools, the camera is useless. In developing a budget strapped strategy, I focused on free web based technology for editing and data storage.

The camera can be an HD camera for less than $150 at any electronics store. A typical camera can record 720P at 30 frames per second to a SD or MicroSD card. The 720P format at 30 frames per second is perfect for theater and television experience. The function of focus and managing the white balance is automatic or can be set automatic to make your filming efforts simpler. More vibrant colors are best captured with outside sun light or indoor halogen lighting targeted at the subject.

From your computer, you can upload from the SD card to your hard drive or cloud storage the video. A camera that is less than $150, will have a built in microphone that will also receive background sound, but it works fine when you control the environment. I've done both inside and outside filming with the camera no further away than 10 feet from the source.

Can you find a better quality camera? Of course. A higher quality will enable a better white balance on color and enable a true enlarged audio mix. Get the camera that fits your budget, but most importantly allows you to produce a good movie.

Lighting

There are lighting needs for outdoor and indoor stage sets. The best lighting for an outdoor setting is a bright sunny day with at the most limited clouds. Natural sun provides the ability for the best white balance when the color setting is automatic.

Indoor lighting is more complex as you need to simulate the brightness and natural effects of sun light. The best light bulb is halogen to provide the most natural effect of sunlight. If necessary, you may use 100 florescent bulbs for basic work, but try to avoid this as it only serves as an emergency backup.

There are four basic lighting arrangements you'll need

* Side Directional
* Ceiling Splash
* Floor Flood
* Shadow Cover

The **Side Directional** light is focused at the subject from an angle to produce an effect.

The **Ceiling Splash** is a light that is shot toward the ceiling at an angle so that it lands on the subject. It provides an over the top lighting that covers a wide area.

The **Floor Flood** is light based on the floor shining up to cancel out the shadows caused by the ceiling splash. Without it the ceiling splash will have shadows under eyebrows, noses, chins. It will also remove furniture features that accent the legs or underside of the furniture.

The **Shadow Cover** is a light that is directed behind the subject directed to the wall to cancel out shadows caused by the subject's shadow from other lighting.

Editing

So that I do not worry about computer requirements, I use cloud computing. I store on SD card and upload to a video editing web site. The best sites are ones that allow you to create a DVD. I use the DVD as the master sent to AMAZON to create print-on-demand DVDs and VOD streaming on Amazon.com

To edit, store, and generate a final product, I use One True Media. To make the film available as DVD and VOD, I use Create Space from Amazon. I'll explain more of these tools later, but first let's focus on editing.

There are six basic editing techniques that serve as the minimum editing needs of a film maker

* Sound
* Clip & Merge
* Text Slide
* Captions
* Effects
* Transition

Sound
Your video will have sound added, for example intro and closing music. As long as you give credit you can get instrumental music from www.FreePlayMusic.com or from the stock from www.OneTrueMedia.com if you are using that as your editing tool.

The editing software will show two tracks. One will show the images and the other (typically shown below) the sound. The images and sound can both be imported. The sound length can be adjusted to match the video length or still image timing.

Clip & Merge
Filming always is wrapped around a rough beginning and a rough ending. The beginning has a pause before subjects start talking and the end when subjects wait to be off camera. The most camera shaking is at the beginning and end during adjustments and wrap up. The editing allows for the trimming at both the start and end so that the clip looks smooth. Multiple clips can be merged together to make a longer clip.

Text Slide
The text slide is used to create the written content at the beginning, end, and in front of a chapter sequence. This is the opportunity to provide information on title, copyright, cast, credits, etc.

Captions
Captions is the text seen as an overlay on images. This might be the name of the person seen in the film. It may be a phone number or web site during a video sequence.

Effects
The effects for some basic editing software is limited. An example may be the light exposure, or antique film look. It may also include an overlay of effects like sparkles or other images. A nice touch is a red curtain opening and closing at the beginning and end of the movie. This gives a nice stage effect.

Transitions
The effect of transitions makes the merging of clips and images smoother. The transition can be a fade from clip to clip or fade to white to next clip or fade to black to next clip. Other transitions have other effects like a screen swipe from left to right or top to bottom, etc.

Other Edits
There are other edits that go beyond the basic simple needs that require some practice to fully take advantage of its use.

Indie Film Production and Publicity

One True Media & Create Space

There are a variety of tools available. The ones I have chosen allows for the current trend of cloud computing and provides a professional low cost product.

One True Media www.OneTrueMedia.com is used to upload video clips to be merged, edited with effects and transitions. You can also add text slides at the beginning, end and in between to show title, credits, and chapter headings. The most valuable functionality of this product is the ability to create a DVD in NTSC format. I've used CreateSpace - www.CreateSpace.com, a subsidiary of Amazon, to make movies available on Amazon as DVD or VOD. Once on CreateSpace, you can generate copies in a nice shrink wrapped case with a professional cover for less than $5 each.

Without A Box

Without A Box is located

https://www.withoutabox.com/

Without A Box is the tool from Amazon that film producers use. It is the connection to IMBb (film promotion) and Create Space (Distribution). It is also the connection to film festivals around the world. You can track the status of your submissions. Promote your film and stream on IMDb, the number one source for films. You can upload clips, interviews, and trailers. You can even upload your full movie. Withoutabox is the portal to IMDb and film festivals around the world. Without a box directs you to Create Space to allow you to sell your film on DVD and Video On Demand.

In summery, Without a box says their free service allows you to:

— Discover more than 5,000 festivals across six continents
— Securely submit films, forms, & fees online to 850 festivals
— Promote your films to over 57 Million fans on IMDb
— Upload screenplays, trailers, clips, posters, & photos
— Get the latest on fests, competitions, & exhibition opps
— Self-distribute on DVD, VOD, & streaming video

13 Indie Film Production and Publicity 13

First Step To Film Festivals

After using all the tools from Amazon, you can start building the experience of presenting your movies to film festivals by first going to www.indieflix.com

Indie flix is an online vehicle to make money. You get 70% and they get 30% of the revenue. To submit a film, go to

http://indieflix.com/pages/filmmaker/

A small film festival is held multiple times during the year at the Springfield Community Festival in Massachusetts. Go to

http://www.SCF1.org

After a film festival or two, you can have your film shown via cable on-demand by submitting to SnagFilms located at www.SnagFilms.com If in the form of a documentary, you may also present your film on PBS.

Next you can step it up by learning more about relevant film festivals by going to Without A Box: https://www.withoutabox.com/

The Modern Movie Theater

A growing number cell phones are smart phones. Tablet computers are becoming more and more available. If your movie is uploaded to YouTube or Vimeo, then the app can be downloaded for easy viewing. Because of cell phones, tablet computers, netbooks, and laptops, movie viewing is portable.

The online movie giant Netflix is no longer alone. There are others in the online movie showing field. The list is below:

- Netflix - www.Netflix.com
- Amazon Prime - vod.Amazon.com, www.Amazon.com
- XFINITY Streampix - www.Xfinity.com/streampix
- CinemaNow - www.CinemaNow.com
- Vudu - www.Vudu.com
- Blockbuster - www.Blockbuster.com
- IndieFlix - www.IndieFlix.com
- Indie Movies - www.IndieMoviesOnline.com
- Snag Films - www.SnagFilms.com
- Vimeo - www.Vimeo.com
- Yahoo - screen.yahoo.com
- MetaCafe - www.MetaCafe.com
- Break - www.Break.com
- Blip.tv - www.Blip.tv

You can go to some of these web sites to find out how to submit your film.

The online viewing devices used by the general public are PlayStation, Xbox, Blue Ray WiFi devices, Smart TV's, tablet computers, cell phones, and cable/satellite provider set top boxes.

Indie Film Production and Publicity

Creating a Movie Theater Event

Some of the basics you'll need to consider are:

- DVD player to run film
- Video projector to convert DVD to screen
- Projector screen or white wall for viewing
- Stereo speakers for audio
- Function hall and seating for customers
- An advertising, marketing, and promotion plan

Venues - Hall Rentals

- Senior Centers
- Nursing Homes
- Church Meeting Rooms
- American Legion - www.Legion.org
- Knights of Columbus - www.KofC.org
- Hall rental from Veterans of Foreign Wars (VFW) - www.VFW.org

Promoting Event

When setting up events, they must be promoted
TV and radio station web sites have calendar community events that can be listed for free. Find radio and TV stations and by zip code at
 www.radio-locator.com & www.yellowbook.com &
www.google.com

From their web site, get news contact info to send a news release that announces your public event.

Networking With Film Professionals

Now that you have produced a film and done some distribution, how can you learn more. Well the rest is up to you. You'll have to engage in networking.

The basic tools are:

- Face book - www.facebook.com
- Linked In - www.LinkedIn.com

Search forums and groups to share information.

There are also other vehicles for networking

- New England Film - http://newenglandfilm.com/

Moving forward you will find other resources. My true wishes are for your success.

# 17 Indie Film Production and Publicity 17

This next section is focuses solely on publicity. We shall call it:

Publicity Made Simple

This section is based on my book with the same title.

18 Indie Film Production and Publicity 18

Introduction

You have a contribution to share. Perhaps it is a public event, a book, a movie, a wonderful invention, supporting a political figure (You?), or something. Really anything. So go ahead and share your contribution! The important thing is you have a contribution and you need to share it. Only the media can help and you need publicity.

Publicity is getting the media to put you in front of your intended audience. That audience may be general or a segmented population based on demographic, geographic, and other market criteria. There's a lot to it.

I have two options to help you succeed. I can take your thousands of dollars to be your publicist or for twenty five dollars I can use my experience to teach you the art of effectively using media to generate publicity that shares your contribution. A decision can be made based on dollars and <u>sense</u>. Or should I say *common* <u>sense</u>. Yes, common sense. I'll let you know now that I'm too busy to take your thousands of dollars. Whew! You just saved a boat load full. Let me teach you instead. Back in the 1980s, I earned a masters degree in education, so a I know a little about effective teaching and learning.

Indie Film Production and Publicity

My Start In Media

I've been doing this stuff for a long time ...

In 1998 when I was director of the New England Publishers Association, I wanted authors to get publicity through media. "Wouldn't it be nice to be able to funnel authors one at a time to a radio show for interviews", I thought. Well my fingers did some dialing and I called one radio station after another. It was the program director and host of the morning show of WORC 1310 AM who answered the phone. He said, "Why don't you interview them?". Looking like a deer staring at head lights, I asked "What?". Well any way, my LIVE radios show "Author Of The Week" aired every Thursday morning from 9AM to 10AM before going into ABC News. The show aired on both WORC 1310 AM and WGFP 940 AM.

I enjoyed my start as a talk show host. My next venture was cable public access television. The show Author Of The Week was turned into a TV show on WCAT in Westborough, Massachusetts.

As a guest, I've also been on national news, news papers, radio shows, and local television. The media, be it broadcast or web, provides a nice soap box to stand on. I learned very early in my publishing career the importance of publicity and how to best use the media as a door way to your customers.

I've been doing this stuff for a long time ...

Behind the Scenes

From behind the scenes, I could see the end result of a talk show for authors. It provided credibility and public awareness of a book. As an author myself who has been on TV, radio, newspapers, internet web casting, I have seen the success publicity makes.

Since 2004, as a college instructor, I've been teaching techniques to get authors, business owners, subject matter experts in the media. Working with students in Massachusetts and Connecticut over many years, I've developed the formula for success using the media to your advantage.

In addition to the strong presence of TV and radio, the web has become a necessity in anyone's media campaign. Broadcast and web cast have their advantages. Broadcast has a local geographic audience during a given time period. Web cast has a broader geographic audience during an extended period of time. When I did my first radio show in 1998, those who heard it listened to it once and that was it. On my more recent web casts, people can listen to a show at any time and so the listening audience grows over times. With tablet computers and cell phones, the audience on the web is anywhere. We live in a very mobile society. Even a year from now, the web will be in its infancy compared to what it will eventually become. It is always growing. This isn't to say that broadcast will go away. Just as TV became an addition to radio years ago, the web is in addition to traditional forms of media today. The media outlet opportunities are growing. I think of Facebook alone a necessary and additional form of media publicity outlet.

21 Indie Film Production and Publicity 21

Prerequisite

A successful media campaign requires the intuitive ability to research on the web. One needs to be able to find resources and not expect media reporters will automatically come to their door. Expect that no one is a publicity magnet and effort is required to get your voice heard. There are so many unwarranted desires for 15 minutes of fame that the custodians of the media are swamped. It's a huge effort to filter out what is reality and what is scam. It's up to YOU to have the ability to climb over the mess and reach over to the most effective resources to provide you with publicity.

Before we talk about the media, we will talk about the way to present you and your contribution to the media. It has to be done in a non-arrogant and non-intrusive way. When reaching to the media, be aware not all will be take your story. Actually a small percentage will. This does not mean your story is of no value. It just means that a "No" means "No" for the moment. There is so much news and the media needs to pick and choose based on space or time availability. But feel better to know that for every "No" you get, you are that much closer to a "Yes". To ensure you get to a "Yes" faster, it is necessary to speak the language of the media so that their effort to turn your story into media presented is easier.

Tools Of The Trade

Your audience may be the general population. To effectively reach them you must use the media. To ensure the media uses you effectively, then your first true audience is the media. There are effective tools of the media trade that I've been teaching at colleges since 2004. They are

- WIIFM - The passion
- RASCIL - The who and the what
- 5 W's - Journalism 101

Don't let the list scare you. You can handle all three. The thing you should be scared about is the potential to be distracted from any of the three. Distraction is the sloppiness of responsibility to reach a goal. You don't want to be stupid sloppy. Be responsible and take action toward success. Be focused and learn from this book and you will do quite well.

All three are tied together and form a nice package for you to present to the media in the form of a written document online and paper. It is also the high level script you use for interviews on TV, radio, and the web.

I've been teaching publicity and media attention for authors since 2004 at colleges and universities. Long before I've been working with the media since 1994. It took 10 years to eliminate the mistakes to achieve the ability to teach on the subject.

23 Indie Film Production and Publicity 23

WIIFM

There are a lot of people who have provided a similar contribution to yours, however yours is different. Different? Why would the media believe that? Why should they care? If they care, then they will share with the general population or segment population. It's up to you to tell the media why they should care. Just saying "I'm great and the best" is arrogant and ignored by the media. Instead tap into their heart and soul through emotion, result, or impact. Use the WIIFM tool to accomplish this. WIIFM describes the benefit to our audience.

WIIFM stands for What's In It For Me. This is what the audience is looking for. They are looking for a benefit. They are asking what's in it for me and why should I care. Without a benefit, they won't care.

WIIFM is defined as follows: WIIFM is the sentence - It or this will make or give you a result or emotion. The result or emotion must be no more than three words. Two words are best. Three words is redlining the effect. In equation form, WIFFM is defined below.

WIIFM = (It/This) will (Make/Give) you ___(result/emotion)__

Using this model, you can discuss WIIFM to your audience in four ways

- It will make you
- This will make you ...
- It will give you ...
- This will give you. ...

Notice that "It" is matched with a "make" and a "give" and "This" is matched with a "make: and a "give". This results in four sentences that represent why someone would benefit from your contribution.

WIIFM Example

The tool WIIFM is defined with the verbal equation

WIIFM = (It/This) will (Make/Give) you ___(result/emotion)__

Four sentences are generated from this equation.

- It will make you
- This will make you ...
- It will give you ...
- This will give you. ...

The result or emotion must be no longer than three words

Let's make an example. Let's suppose a cardiologist wrote a book about eating healthy. Examples of WIIFM might be as follows:

- It will make you healthy
- This will make you eat right
- It will give you good eating habits
- This will give you long life

Notice how the four sentences are direct and to the point without rambling. Just say it and leave it.

This may sound simple and easy for me to explain, but when put in practice, it is difficult. When I teach this in a college class room most students make the mistake of taking the final result/emotion and rambling on word after word. Some fall off the track and don't use the template at all and I end up stopping them and pointing to the WIIFM equation on the board.

Think of you closing your eyes stepping out of your body, turning to your self and pointing to your self and saying It will make you ... or some other WIIFM sentence. I know it's hard and needs practice.

Indie Film Production and Publicity

WIIFM Practice

The tool WIIFM is defined with the verbal equation:

WIIFM = (It/This) will (Make/Give) you ___(result/emotion)___

Four sentences are generated from this equation.

- It will make you
- This will make you ...
- It will give you ...
- This will give you. ...

The result or emotion must be no longer than three words. Beyond that you are red-lining and out of control. Don't do it. Be to the point.

Think of your contribution and the benefit it is to your audience. Now use WIIFM.

- It will make you _____

- This will make you _____

- It will give you _____

- This will give you _____

This will tell your audience that your contribution is your passion and that it can benefit them.

Get a note pad and brain storm. Take the dedicated time to practice. This is an important tool to attract attention to the media who in turn reaches to your audience.

RASCIL Defined

RASCIL defines the who and the what about your contribution. It originates as a tool to create print advertising in the yellow page directory. I was well practiced with this when I created print advertising with TransWestern Publishing (bought out by Yellow Book).

I'll give you an example of how it might be used to create print advertising. Let's first define what RASCIL Factors are:

R = Reliability How long have you been contributing?
A = Authenticity Certifications or other credible evidence
S = Simplicity How easy is it to get your product or service
C = Completeness What are all the benefits from the features
I = Illustration The over all look and/or packaging
L = Location Where can the product or service be found?

A typical yellow page ad might represent a nice garage that repairs cars.

R = Since 1976 (length of service)
A = Certified Mechanic (fully trained)
S = Drop off at 7AM and Open till 7PM (easy scheduling)
C = Brakes, Mufflers, Tune-ups, Oil Changes, (multi service)
I = Image of clean garage floor, tools nicely arranged
L = 123 Main St, tel # 617-555-1212, **www.website.com**

The ad in the yellow pages would have all this information so that the reader can get the full story with a quick look. In short the reader gets the <u>who</u> and the <u>what</u>. Yellow page ads in phone books and online work best for doctors, lawyers, trade workers, restaurants, and other service industry businesses. Quick searches enable seekers to quickly find the <u>who</u> and the <u>what</u> and make choices based on their need.

Indie Film Production and Publicity

RASCIL Example

Let's use the cardiologist example used previously. Let's say a cardiologist wrote a book about eating healthy. Remember that heart surgeons among other things, see the result of obesity and know that eating right can prevent the need for surgery. It makes sense that a cardiologist might write a book about eating healthy. But so many other authors write books about eating healthy. I am one of them and wrote "Delicious Success To Your Health". So that people can make a choice, they may want to first see what is available by understanding the "Who" and the "What" that comes from the RASCIL factors.

R = Reliability How long have you been contributing?
A = Authenticity Certifications or other credible evidence
S = Simplicity How easy is it to get your product or service
C = Completeness What are all the benefits from the features
I = Illustration The over all look and/or packaging
L = Location Where can the product or service be found?

Using the RASCIL factors, let's use the cardiologist as an example.

R = Practicing medicine since 1982
A = Award winning cardiologist, medical degree M.D.
S = book available online and in stores (paper and ebook)
C = Exercise, healthy recipes, medical advice
I = Picture of doctor in white coat with stethoscope around his neck
L = www.website.com, 1-800-toll free #, Barnes and Noble

Notice how the RASCIL factors give a **who** and the **what**. The audience can gather this to make choices. More information is needed for the media to be attracted. So far WIIFM has been used as a tool, but there is more. First let's practice RASCIL to ensure a full understanding. As with WIIFM, it is easy to describe RASCIL, but hard to put into practice.

RASCIL Practiced

Let's remember the definitions ...

R = Reliability How long have you been contributing?
A = Authenticity Certifications or other credible evidence
S = Simplicity How easy is it to get your product or service
C = Completeness What are all the benefits from the features
I = Illustration The over all look and/or packaging
L = Location Where can the product or service be found?

Now think of your contribution. Tell the media who you are and what your contribution is.

R = Reliability _____

A = Authenticity _____

S = Simplicity _____

C = Completeness _____

I = Illustration _____

L = Location _____

So far we've learned WIIFM and RASCIL. Our attention has been on RASCIL and so now we need to go back to WIIFM so that we don't forget it. We need to keep our new tools in practice. Before learning new tools, focus on WIIFM and then RASCIL. As I said before, it is very easy to explain, but hard to put in practice.

More Practice With WIIFM

The tool WIIFM is defined with the verbal equation:

WIIFM = (It/This) will (Make/Give) you ___(result/emotion)___

Four sentences are generated from this equation.

- It will make you
- This will make you ...
- It will give you ...
- This will give you. ...

The result or emotion must be no longer than three words

Think of your contribution and the benefit it is to your audience. Now use WIIFM. Get a blank paper and practice. When you are done, do it again.

- It will make you _____
- This will make you _____
- It will give you _____
- This will give you. _____

Now let's go back to RASCIL and practice more. With WIIFM and RASCIL perfected, we will be able to move on to the final tool that adds more and pulls WIIFM and RASCIL together.

More Practice With RASCIL

RASCIL is defined as follows.

R = Reliability How long have you been contributing?
A = Authenticity Certifications or other credible evidence
S = Simplicity How easy is it to get your product or service
C = Completeness What are all the benefits from the features
I = Illustration The over all look and/or packaging
L = Location Where can the product or service be found?

Now think of your contribution. Tell the media who you are and what your contribution is. Get some paper and do some more practice.

R = Reliability _____

A = Authenticity _____

S = Simplicity _____

C = Completeness _____

I = Illustration _____

L = Location _____

Next we'll use a tool that adds more and pulls WIIFM and RASCIL together.

The 5 W's - Journalism 101

The 5 W's is considered Journalism 101. We will use it to add more to our story to the media and to tie WIIFM and RASCIL factors together. The prerequisite to this discussion is the time spent on honest practice of WIIFM and RASCIL factors. That way further discussion isn't confusing. Did you practice? No? Then it's time to go back before going further. (I know, it's so easy to flip forward in a book)

No really ... go back.

Are you kidding me? If you want publicity to be a success for you then you need to practice-practice-practice.

The 5 W's Defined

The five W's are quite simply Who, What, When, Where, Why. It is the content in reporting and is considered "Journalism 101".

WHO: Your Name, Your Title, Who you are

WHAT: What Happened, Your Contribution

WHEN: A time frame that explains "When?"

WHERE: A location or a place that explains "Where?"

WHY: The reason that gives purpose and satisfaction

Let's tie WIIFM and RASCIL factors to the 5 W's. The WHO and the WHAT comes from the RASCIL factors. The WHY comes from WIIFM.

```
WHO    =   RASCIL
WHAT   =   RASCIL
WHEN   =   A time frame that explains "When?"
WHERE  =   A location or a place that explains "Where?"
WHY    =   WIIFM
```

The 5 W's can also be looked at like this

```
RASCIL =   WHO & WHAT
WHEN   =   A time frame that explains "When?"
WHERE  =   A location or a place that explains "Where?"
WIIFM  =   WHY?   (It/This) will (Make/Give) you ____
```

Indie Film Production and Publicity

Example of 5 W's

Again, let's use the cardiologist who wrote a book on healthy eating as our model example.

WHO	Dr. John Doe ("Dr." is from RASCIL)
WHAT	Book Signing for book on healthy eating
WHEN	Next Week (book signing)
WHERE	Barnes and Noble Book Store
WHY	It will give you healthy eating habits (WIIFM)

There is no set way to use the RASCIL factors. Use it as a guide to give you elements about the WHO and the WHAT. It will help you develop the 5 W's.

The story about the cardiologist and his book can be said differently using the 5 Ws. As you see this keep in mind the WHEN is any type of time frame and the WHERE is any type of location. As before the RASCIL factors will help define the WHO and the WHAT. Here is the 2nd usage of the 5 W's

WHO	Award winning cardiologist with new book
WHAT	Eating Right Is Necessary (also title of book)
WHEN	It is never too late (time frame given)
WHERE	All Across America (location given)
WHY	This will make you eat right (WIIFM)

Notice in both examples we discuss a cardiologist and his new book about eating healthy.

Practice With 5 W's

Here is our opportunity to pull WIIFM, RASCIL, and 5 W's together. Remember to use RASCIL as a guide to create the WHO and WHAT. Use WIIFM to create the WHY.

- Who
- What
- When
- Where
- Why

Now write a paragraph using the five sentences above.

Next write the same thing, but in a different way just like the cardiologist example.

- Who
- What
- When
- Where
- Why

Now write a paragraph using these five sentences.

What you have just learned is the starting elements to create a news release as part of your media campaign.

Your Next Step

Your next step is to turn one page back. You didn't practice the 5 W's sufficiently. Again, it's too easy to flip forward one page at a time.

Really ... Go back.

I've been teaching publicity at colleges for authors since 2004. After years of teaching, I now tell my students that about 80% won't succeed because they haven't sufficiently practiced the language of the media and the necessary intense follow through.

So let's do it ! Pull WIIFM, RASCIL, and 5 W's together. Remember to use RASCIL as a guide to create the WHO and WHAT. Use WIIFM to create the WHY.

- Who
- What
- When
- Where
- Why

Now write a paragraph using the five sentences above.

Next write the same thing, but in a different way just like the cardiologist example.

- Who
- What
- When
- Where
- Why

Now write a paragraph using these five sentences. It will take time to make the sentences flow from one sentence to the other, but it will happen.

Real News Release Example

This is a news release that I made for an author. It resulted in a broadcast radio interview, two feature newspaper articles, a book signing in a major bookstore chain, and placement in a local independent book store.

This is what was sent to local media.

Donation to Noble Visiting Nurse and Hospice to be made by Westfield, MA resident

Jul 09, 2009 – Jeannie-Miller Poland of Westfield, MA is the wife of Gary Poland who passed away last year of Cancer. Her book "Prince Gary" that talks about the ordeal before and after his death will be released in August 2009. A portion of the sale of the book will be donated to Noble Visiting Nurse and Hospice of Westfield. The book is being released on August 18th, Gary Poland's Birthday and nearly one year after his passing. Gary Poland was a native of Westfield, MA and a 25 year veteran of Comcast. The book Prince Gary will make you cry. It will remind you to "Love Longer, Hug Harder, Touch Softer, Talk Sweeter and Forgive Faster" Donation to Noble Visiting Nurse and Hospice of Westfield and to provide a thank you for the support from friends and family.

The next page breaks down the news release

Indie Film Production and Publicity

Breaking Down The Example News Release

Below is the break down of the news release into the 5 W's.

(1) Who: <u>Jeannie-Miller Poland of Westfield, MA is the wife of Gary Poland who passed away last year of Cancer</u>

(2) What: <u>Her book "Prince Gary" that talks about the ordeal before and after his death</u> will be released in August 2009

(3) When: Her book "Prince Gary" that talks about the ordeal <u>before and after his death will be released in August 2009</u> ... Gary Poland was a native of Westfield, MA and a <u>25 year veteran of Comcast</u>.

(4) Where: <u>Jeannie-Miller Poland of Westfield, MA is the wife of Gary</u> Poland who passed away last year of Cancer ///// <u>Gary Poland was a native of Westfield, MA</u> and a 25 year veteran of Comcast.

(5) Why (WIFFM) : <u>The book Prince Gary will make you cry.</u> ////// <u>It will remind you to "Love Longer, Hug Harder, Touch Softer, Talk Sweeter and Forgive Faster"</u>

(6) Another Why (WIIFM): Donation to Noble Visiting Nurse and Hospice of Westfield and to provide a thank you for the support from friends and family.

How To Use 5 W's

Once you have become well practiced with the 5 W's it's necessary to put it to good use. The 5 W's is the language of the media and your door way to an interview. Take the time to prepare your material right the first time to ensure credibility.

- Your Web Site (Later we cover how to get one)
- News release sent to the media
- Sharing Info On Social Media Sites
- Business Cards, Brochures, Flyers
- Your Interview with the media

The 5 W's is the language used to present your contribution (product/service) to the media and to the general public or segment population. It is not arrogant and is non-intrusive.

The way I create good content using the 5 W's is by first by creating an outline. I write out topic headings: WHO, WHAT, WHEN, WHERE, WHY. Under each heading, I write appropriate information. Then I make it flow.

Indie Film Production and Publicity

Creating Your Own Web Site

You need is create a web site as your web based online representation. It serves as your resume and provides contact information. A web site is more than a business card. It is an interactive tool for your audience. Various media content can be made available. If you have a product or service to sell you can have consumers purchase online. If you have the intuitive ability to manage pages on the web, you can create a site for free.

Some good do-it-yourself resources to create your web site from nice looking templates are:

<p align="center">www.web.com
www.webs.com</p>

There are others and you can find them on the web by searching with *"Free Web Sites"*.

The end result is a web page that has a main page with tabs or menus for other page locations. You can add HTML embed code to insert videos or widgets for example PayPal merchant buy buttons.

Next you want a title or URL of the web site that will best represent your name. It is called a domain name. Your web site will start with a "www" and end in a dot com or dot net or dot info. Take a look at:

<p align="center">www.GoDaddy.com
www.Register.com</p>

With these resources, you direct your selected domain name to point to the web page you created from "web" or "webs" (see above). So when someone enters www."your-site".com, it will be directed to the web page you created from **www.web.com** or **www.webs.com**

Other Useful Web Sites

Make the web site fancy by recording and uploading a video to YouTube and embed the HTML code to your web site. It is a great way for you to talk to your potential customers each time they visit your web site.

If you've convinced your customer, a PayPal buy button will let online purchased be made to your web site. Just like YouTube, PayPal has customized HTML embed code for your web site. Learn more at **http://www.PayPal.com**

Make the web site visible by sharing it with friends of Facebook, MySpace, and Twitter. Include it on your press releases, business cards.

There is a way to share spread sheets, presentations, and documents on your web site. Google has a great tool **http://docs.google.com**

You can also share free e-books or newsletters. Create the document in Word format (.doc) and convert to a PDF file using www.PDFonline.com (free tool). Then upload it to your registered account at **www.Issuu.com** HTML embed code is available to insert to your web site. In summary

 (1) Create document in Word
 (2) Convert to PDF file (www.PDFonline.com)
 (3) Upload to www.Issuu.com
 (4) Share by inserting embed code on your web site

Indie Film Production and Publicity

News Release

Previously I shared a news release story of an author Jeannie Miller-Poland who wrote the book Prince Gary. Here's more.

A News Release is the announcement of your contribution and invitation for the media to learn more by contacting you. The 5 W's is the communication of the media so they will be enticed to reach you if you talk their language.

In a later section you will learn how to reach all the newspapers, radio stations, web sharing sites, etc. For now we will learn how to write a news release.

The subject and title of the news release needs to include a subject (noun), an action (verb), an impacting result, and a message. It must be short and entice the audience to read more.

- Subject (Noun)
- Action (Verb)
- Impact
- Message

Using the cardiologist example we've been using a good title of a news release could be *"Cardiologist Saves Lives With Good Eating"*. In this example see how each part breaks down as follows:

- Subject (Noun) = Cardiologist
- Action (Verb) = Saves
- Impact = Saves Lives
- Message = Good Eating

The rest of the news release is the 5 W's and your contact information. End the news release by stating: *"For more information, contact ..."* or *"Media are invited to contact ..."*

Sharing News Release Online

Internet searchable news releases can be entered online and later shared through social media sites like Facebook and Twitter. Look at the following online tools

> PR-web: www.PRweb.com
> PR-Log: www.PRLog.org

These sites require you to sign up for free by creating an ID and password. You will have a private account to manage all of your press releases.

These tools provide HTML coding and also links to include the news release content on your own web site. Web link to a PDF file is also available so that it can be shared on your web site or anywhere else.

Aside from the PR-web and PR-Log, emailing is a powerful way to reach media contacts and invite them to learn more. The media is always looking for good content, but only chooses what they feel is marketable. Again, by speaking the language of media people, they will more likely be enticed.

When you invite the media to contact you, one of the first places they go before calling by phone is your web site. Ensure your news releases are found there. PR-web and PR-log have the ability to share a link to a PDF file or HTML code for embedding.

The Outlets of Media

You want your voice heard. That's a good thing. Standing on the street corner isn't going to work. Using affective means to reach the media and use them as your soap box to stand on will work. Look at the list below and be aware that your successful media campaign will use all of them.

Television
 National and local Broadcast TV
 Local cable access TV

Radio
 Broadcast Radio (AM & FM) and internet radio

Newspaper & Print Media
 Local Newspaper, Free weekly paper
 Web articles

Social Media
 Facebook, Myspace, Twitter, LinkedIn
 Email blast services

United Postal Service
 Mail letters

Speaking Events
 National, Local, Colleges

Personal Web Site
 Summary and contact information

Let's explore some of these options.

Newspapers

Newspapers are in print and online. Some are online. The Christian Science Monitor from Boston started as a paper newspaper, evolved into a hybrid (both paper and online), and today is now only and online newspaper. The readership of newspapers continues strong, but the paper distributership has been going down. Today people can subscribe to newspapers on their Kindle or Nook e-reading device or view the paper web site online either by computer or cell phone.

The advantage of a feature article in a newspaper is it serves as a 3rd party review of you and your contribution. This written testimonial serves as part of your media kit as you seek media attention from radio and television.

To find newspapers, go to:

http://www.findnewspapers.com/
http://www.newspapers.com

You will have find web sites to give you contact information.

You can also check out your local free weekly papers that are in print and online. Take advantage of those. Local papers are always looking for local heroes. Once you have one local article, that will serve as part of your promotional kit to seek bigger media outlets with a broader reach to an audience.

Indie Film Production and Publicity

Online Feature Articles

It's great to get a feature article in the newspaper to serve as your media kit to reach out to radio and TV stations. In today's world, feature articles don't only come from newspapers. There are online resources too. Have you ever read an article on the internet and wondered how it gets produced? The writers are paid a commission to write online articles and therefore have an incentive to produce good content.

<p align="center">www.Examiner.com
www.Suite101.com</p>

I have serve as a reporter and journalist for both and am familiar with their credibility.

Search for articles that are similar to your contribution. You'll be able to find the contact information for the reporter. Remember to use the tools of WIIFM, RASCIL, and 5 W's when reaching a reporter.

This is a great way to get a feature article for your contribution. Once you have it, the article will serve as your media kit to help you reach radio and TV. How does that work? Just send a cover letter with the article and some photos. It makes for a great promotional package.

Radio Shows

Years ago people thought that the rise of television would make radio go away. It didn't. What happened was is television became an addition to radio. This happened a generation earlier when radio became an addition to newspapers. Media outlets stay and others become an addition. There are those that find social media sites are additional media outlets. Today CNN and other world news media use social sites to communicate with and report to their audience. That being said, be aware that radio is here to stay and should be used as a strong outlet.

The benefit of being a guest on radio is you can be at home on the phone as a guest. People have done tours across the country (while at home) in their bath robe and bunny slippers.

There are three types of radio shows

- Broadcast
- Internet
- Satellite

Broadcast radio shows air from AM and FM signals that land on antennas connected to a radio. Listeners have to be in the geographical vicinity to hear the show. They can also be remote and listen on the web as many stations stream shows LIVE online.

Indie Film Production and Publicity

Broadcast Radio

How do you find radio shows to send your news release? You search on the web.

A great web site is

http://www.radio-locator.com/

I've been sharing this web site with students for years. It's been a great reliable tool for finding shows

You can search by any one of the following:

- City or zip code
- Call letters
- Internet streaming stations
- World radio stations

Look for talk shows and after running a search criteria you can click on the Call Sign of the radio station to get their web site. You can get their contact information from their web site. Spend dedicated time retrieving contact information from as many talk shows as possible.

Internet talk radio shows can also be found on Blog Talk Radio network. Look at www.BlogTalkRadio.com There are always hosts looking for guests to sign on.

Internet Radio Shows

More recently, I've been hosting shows on internet radio. The advantage is it is conducive to my busy schedule as I can host a show from my home office. Internet radio shows have the advantage of LIVE streaming and saved pod cast. Shows previously aired are shared as a link that can be emailed, posted on a social web site, and available on your web site. Your web site can tell more about you by sharing a conversation with a good talk show host.

Take a look at the following:

- http://www.BlogTalkRadio.com
- http://www.voiceamerica.com/
- http://www.wsradio.com/
- http://webtalkradio.net
- http://www.worldtalkradio.com/
- http://www.globaltalkradio.com

Find more by searching the web "Internet Talk Radio". I enjoy hosting my shows on www.BookRadioStation.com I interview authors and book publishing experts.

As I write this page for this book, I went to Blog Talk Radio and found the show I was a guest on several years ago and posted it on Facebook just at this moment. It's nice that radio interviews on the web can be used over and over again. It's a way of taking full advantage of one interview. If someone didn't hear the interview today, they will tomorrow, or the next day.

Indie Film Production and Publicity

Satellite Radio

Radio doesn't end at broadcast and internet. Take a look SiriusXM satellite radio. It is a world radio resource.

Authors can look at http://www.siriusxm.com/bookradio

To look at other talk radio venues on satellite, go to

http://www.siriusxm.com/talk&entertainment

So what have we learned? Radio is complicated. It's on three types of media:

- Broadcast
- Internet
- Satellite

I love them all. Hidden are so many stations and so many talk shows that are available to you. It's your homework assignment to find the shows that fit your topic and to reach out to them.

The Future and Media Formats

Social media sites are a whole new world of communication. Internet radio is the radio of that world. As social media sites evolve, internet radio will become a more powerful form of media. Take full advantage of this resource. As I said before, it's nice to conduct a media tour in your bath robe and bunny slippers.

As a talk show host who originated in broadcast radio, I now focus my attention on internet forms of media. Certainly traditional media formats aren't ignored. I would never do that. I'm saying that I'm not afraid of the future. Remember that TV did not eliminate the radio as radio did not eliminate the newspaper. Media evolves and with it so should you. The long standing forms of media have evolved and can be used to reach a broad audience. Use that to your advantage.

The prerequisite to understanding how publicity is made simple is to have the intuitive ability to use the internet as a research tool. Computers are a necessary part of the media world today. It can't be avoided. You also have to think realistically and be grounded. I mean truly grounded in the world of reality. This will allow you to be honest with WIIFM, RASCIL, and the 5 W's. With constant practice, you can succeed. During your constant practice, you will also evolve with the technology as each form of media

Television Stations

Many local TV stations have people come on as guests to discuss their expertise or contribution. I remember being on WWLP, channel 22 News to talk about my book "An Easy Cooking Lesson For You". Proceeds of the book went to a charitable cause and announcing it on television helped broaden awareness.

The web site below gives TV station news, search ability for top 100 markets and local markets.

<p align="center">http://www.stationindex.com/tv/</p>

Another search tool is

<p align="center">http://www.tvfind.us</p>

Other tools can be found by searching "Search TV Stations" on the web.

Many TV news segments are now shared online either on the station web site and/or uploaded to YouTube. A link or HTML embed code can be shared on your web site and serve as a testimonial to your contribution.

Your broadcast stations aren't your only resource. Your town has a cable company and has a local access cable TV station. Wonderful content is created by local talent to create shows. Check with your cable company. I've enjoyed developing content for two stations. Talk shows are being developed, produced, and broadcasted on local cable access TV stations all the time. While I write this book, I am enjoying my time at a Comcast cable access station.

And Finally ...

So what have we learned? We learned that publicity involves reaching out to the media using their language. And that language is WIIFM, RASCIL, and 5 W's. After some practice, we learned how to produce a news release that is the communication to the media. They listen only to their language so speak it! We also learned how to reach traditional media such as newspaper, radio, and television. Going further we discovered modern developing technologies like the internet and satellite radio. Next week there will be something new that has never been thought of.

What's the next step you ask? If you understand that effort is required to keep the initial momentum going, you'll do OK. Those that fail, figure one big push at the beginning is enough. Well, they fail and learn the hard way. Once you have a contribution requiring publicity to make it shine, you have a very short amount of time before it becomes old news. That fifteen minutes of fame people talk about is really only fourteen minutes.

You have everything to succeed. It's up to you to make it happen. My best to your success. And when success is achieved you have my sincere congratulations!

David K. Ewen, M.Ed.
Ewen Prime Company

www.ingramcontent.com/pod-product-compliance
Lightning Source LLC
Chambersburg PA
CBHW021044180526
45163CB00005B/2275